Faces of Hope

FACES OF HOPE

Babies Born on 9/11

Christine Pisera Naman

Health Communications, Inc.
Deerfield Beach, Florida

www.bci-online.com

A portion of the proceeds from this book are being donated to the
Twin Towers Orphan Fund.

©2002 Christine Pisera Naman
ISBN 0-7573-0097-9

Publisher: Health Communications, Inc.
 3201 S.W. 15th Street
 Deerfield Beach, FL 33442-8190

R-10-02

Cover design by Larissa Hise Henoch
Inside book design by Dawn Von Strolley Grove

To my parents, Frank and Angie Pisera: Everything I do is because of you. You are my greatest blessing. You gave me my life and taught me how to live it. Never were there two better parents. Never was there a greater love.

To my brothers, Rock and Dan: Remember when we were little and I would do anything to be with you? I still love you like that.

To Lisa, the sister I never had but found: Thanks for being my friend.

To Matthew, Diana, John, Marissa and Nina: Love you like crazy, babies.

To Peter, my husband, my friend and my love: Je t'aime, Habibi. Wait until I tell you about my next idea!

To my children, Jason (Jaseman), Natalie (Matlie-Girl) and Trevor (Trever-Ever): My reason for everything. You are my heart. Mommy loves you babies.

Contents

Contents

To the Mothers and Children

To all of the moms who brought good people into the world on a day when it needed it most.

To all the babies who had the courage to be born into the world on a day when the world didn't even have the time to welcome you. We know you will make the world a better place. Be good.

To all the moms who gave birth to babies whose fathers were lost on September 11, 2001. You are our heroes. We won't profess to know your pain or struggle. But our hearts are with you. We all get up in the morning for the same reason. We all go on because there are babies to raise.

To all of the children who lost someone they loved on September 11, 2001. I'm sorry you heard words that no child should ever hear.

To all of those who lost their lives on September 11, 2001. Thank you for your courage and your bravery. We will never forget.

Introduction

Having a baby on any day is a special experience; having a baby on September 11, 2001, was especially unique.

Every new mother cradles her newborn in her arms on the day that it is born and wonders what kind of world she has just brought this tiny, innocent little being into. Every new mom spends at least a few moments on her baby's first evening of life wondering what kind of world we live in. Mothers who gave birth on September 11, 2001, were no exception. They just had more company with their wondering than most new mothers do.

Almost everyone sat somewhere that night wondering what type of world we were living in.

I did, too. As I sat in my bed on the maternity floor of a Pennsylvania hospital holding my newborn son, Trevor, I, too, was wondering what type of world I had brought this sweet little baby into. While I held him, caressing his tiny fingers and toes, marveling at his perfection, I prayed it was a good one.

As the television in the corner of the room droned on relentlessly,

the experts took turns trying to explain the unexplainable tragedy that had rocked the world.

I wiped a tear from my eye for the victims whose lives had been cut short with so much life left yet to enjoy. My heart ached for the victims' families who were living their worst fear. I cried for the children whose parents were explaining with words what no children's ears should ever have to hear—that someone that they loved was now gone—while my own husband was home explaining to my children about the birth of their brother and the miracle of new life. I felt guilty that I was feeling blessed on a day when so much sadness had touched so many.

As my baby drifted off to sleep, I whispered to him, "No one will ever forget your birthday." As his breathing became soft and regular, the announcer on the television explained to me that definitely indeed there were bad people in this world. I prayed that my baby would never meet one. I held him tighter, wishing that I could always keep him this safe, but knowing sadly that I couldn't.

I held him, dreaming dreams, hoping hopes, wishing wishes and praying prayers for the life I wanted him to have.

I wondered if other new moms who had babies that day were having similar thoughts. Together we share something unique.

The serious voices reverberating from the television anxiously tried to make sense of evil, all the while knowing there was no sense to it. Instead, they settled for explaining what had happened because trying to explain why was impossible.

I stared at my baby's innocent face. He was a good person born on a bad day. I wondered why he had not been born yesterday or tomorrow. Everyone who called to wish me well politely congratulated me before mentioning his tragic birth date. "Babies come when they are supposed to come," I would automatically say back to them.

It wasn't until the dark, still moments of that night, after I had turned off the television and was staring out of the hospital window into the black, did my own words come back to me. The words danced around me arranging themselves in fragments of sense.

Babies come when they are supposed to come, I thought. This I know is true. I walked over to the bassinet where my baby was sleeping. Tears from my eyes fell onto his baby-blue blanket. I studied his tiny face, and in it, I saw goodness. I saw peace. I saw hope. Maybe babies born on September 11, 2001, were supposed to be born on that day. Maybe because it was a tragic day, other non-tragic things needed to happen. Maybe because it was a day when life was taken, life needed to be given. A day when

innocence was lost, so innocence needed to be born. A day when sadness had befallen us, so happiness needed to whisper through. It was a day when hope had been stomped on, so new hope needed to surface.

Every pregnant woman spends nine months caressing her tummy and wondering. Wondering who is in there, wondering what they will be, what they will do. One thing all mothers wish for their children is that whoever they are, whatever they do, whatever they become, they will be good.

I began to realize my baby and all of the ones who joined him in being born on that day had a very special purpose. They were born to provide life, hope and goodness to a world on a day when it needed it most. Because on that day, life, goodness and hope had been taken. They were not born to replace anyone. That would be impossible.

But they were born to remember. When they are older, we mothers will see to it that they know, see and remember the faces of the lost. This will help to inspire them to go on for themselves and for others. When they are older, we will remind them of all of the bravery displayed that day. We will tell them that they displayed their own bravery that day, by having the courage to be born on a day when the world didn't even have the time to welcome them. We will thank them for coming. And we will tell them to go out and do good. Because that is why they were born.

A baby does not have to be yours

for you to be able to see the promise of the future

in its face. Anyone can see it. I hope whoever you are,

however September 11, 2001, touched you,

that you will be able to see the hope

in the faces of these babies.

I hope it will remind you that everything will be okay.

I hope you always remember where you were born

and never forget what a privilege it was.

I hope you are someone's dream come true.

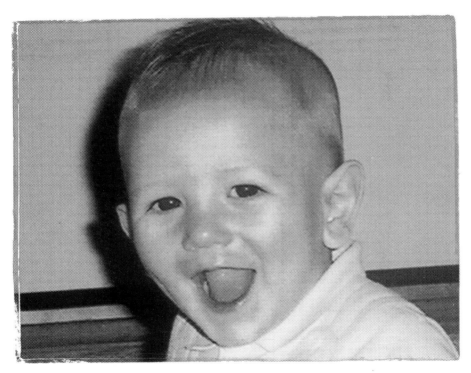

James Michael Blake • Alabama • 9:27 A.M.

I hope you love life.

I hope you run barefoot in the grass.

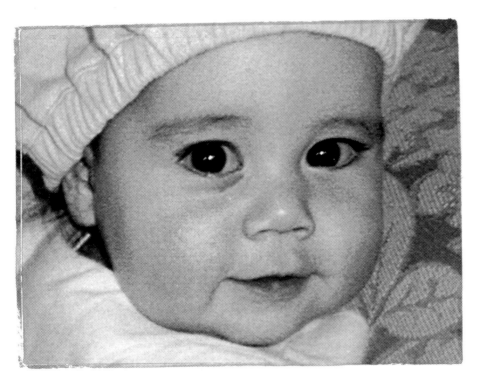

Alyse Shania • Alaska • 12:24 P.M.

I hope you always have more than you need

and share your plenty.

I hope you swim in the ocean.

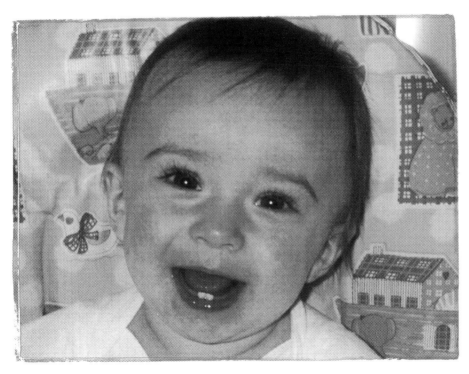

David Michael • Arizona • 10:24 P.M.

I hope you live free, never taking that freedom for granted.

I hope you paint with your fingers.

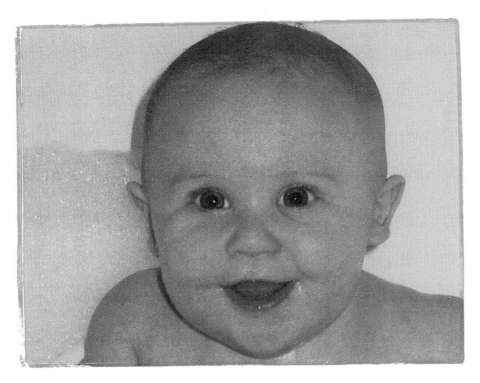

Harrison Graham • Arkansas • 5:22 P.M.

I hope you never lose your spirit.

I hope you catch snowflakes on your tongue.

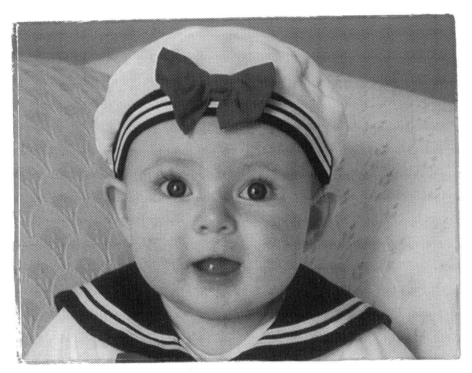

Chelsea Celeste • California • 6:49 P.M.

I hope you nourish your mind, body and soul.

I hope you ask "Why?"

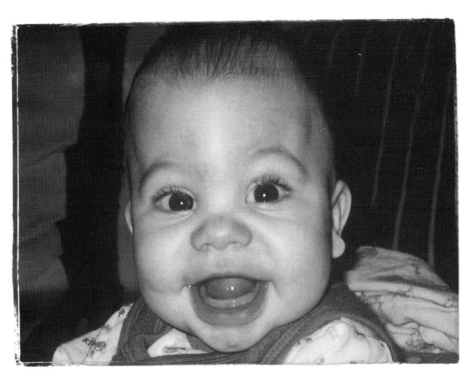

Seth Joseph • Colorado • 7:01 P.M.

I hope you learn to say please, thank you and I'm sorry, and really mean it.

I hope you spin in circles just to get dizzy.

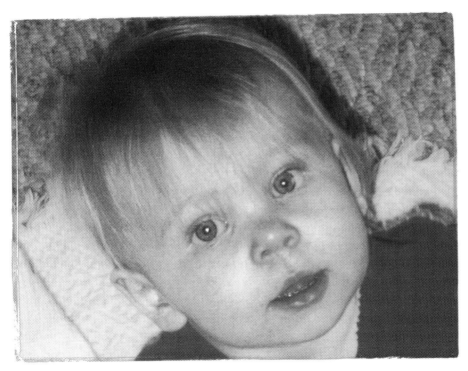

Madelyn Jayne • Connecticut • 3:05 P.M.

I hope you do work that inspires you.

I hope you laugh a lot.

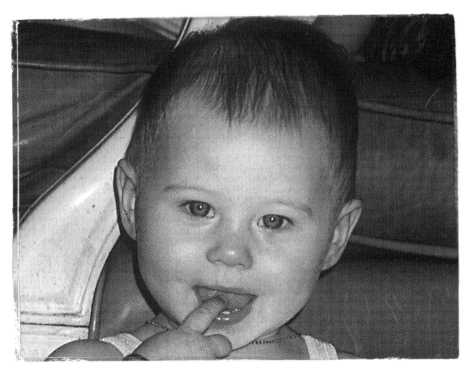

Laura Kathryn • Delaware • 6:01 A.M.

I hope you give to others.

I hope you think your mommy is the nicest

mommy in the world.

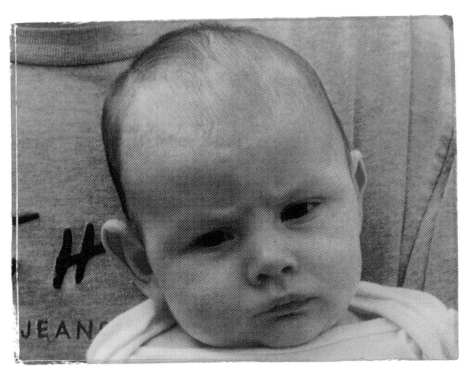

Christian Blake • Florida • 9:48 A.M.

I hope you are honest.

I hope you color outside of the lines

and that everyone says it is beautiful.

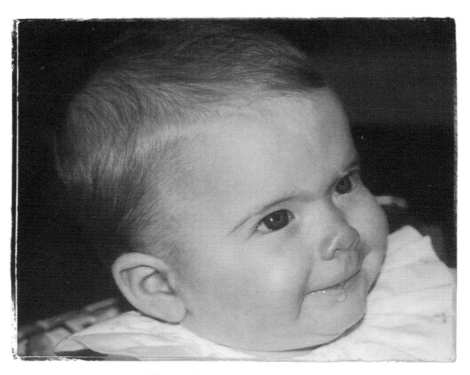

Ellie • Georgia • 5:15 P.M.

I hope you are proud to be an American.

I hope you stand on your head just to see what the world looks like upside down.

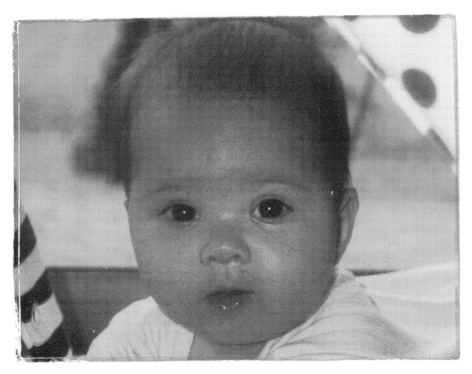

Krystal Chino • Hawaii • 2:56 P.M.

I hope you right wrongs.

I hope you do somersaults.

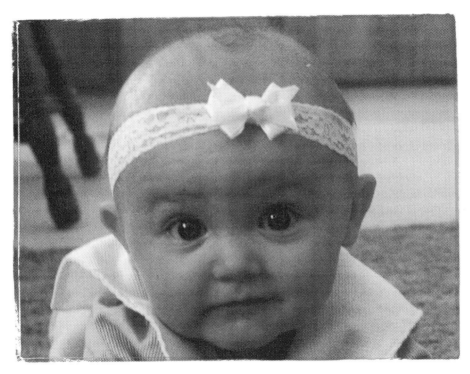

Jenna Kay • Idaho • 1:13 P.M.

I hope you pass on the chance to gossip.

I hope you fall in love with your teacher.

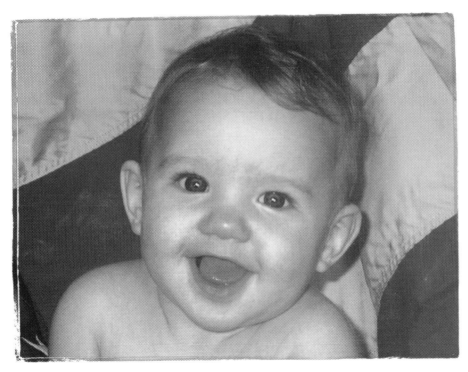

Jacob Michael • Illinois • 2:46 A.M.

I hope you find good in all people.

I hope you climb trees.

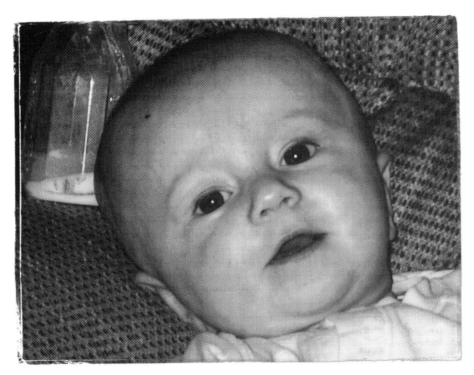

Isaac Gregory • Indiana • 9:54 A.M.

I hope you take away someone's pain.

I hope you make wishes upon stars.

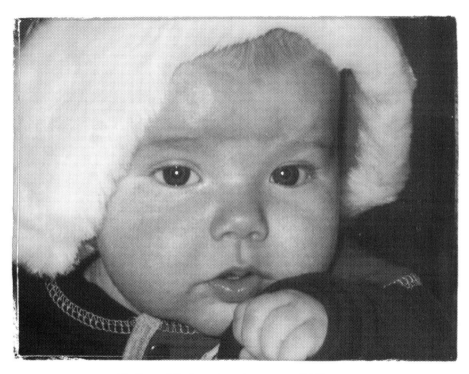

Colton Michael • Iowa • 3:30 A.M.

I hope you teach.

I hope you sleep in a tent in your own backyard.

Savannah Grace • Kansas • 2:48 P.M.

I hope you are proud of yourself.

I hope you build a snowman and give him

your hat and scarf.

Draven Cale • Kentucky • 6:47 P.M.

I hope you talk to God every day

and know that He hears you.

I hope you give an apple to a teacher.

Colby Allen • Louisiana • 8:17 P.M.

I hope you show kindness when others are unkind.

I hope you blow bubbles in your drink.

Seth Michael • Maine • 7:50 A.M.

I hope you help those in need.

I hope you see rainbows.

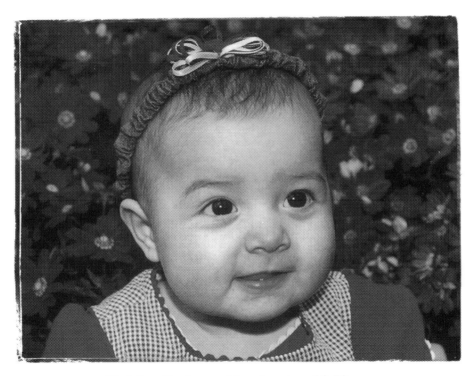

Christina Taylor • Maryland • 12:50 P.M.

I hope you know all of the words to the national anthem and sing it with your hand over your heart.

I hope you jump in rain puddles.

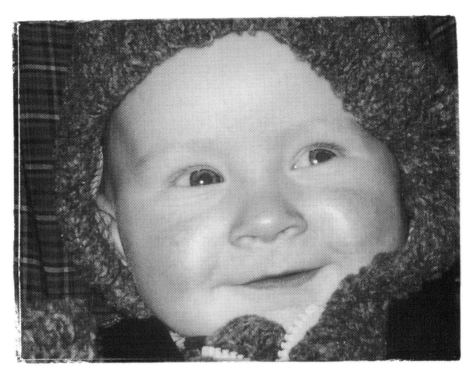

Duncan Andrew • Massachusetts • 3:14 A.M.

I hope you welcome strangers.

I hope you lie in the snow and make angels.

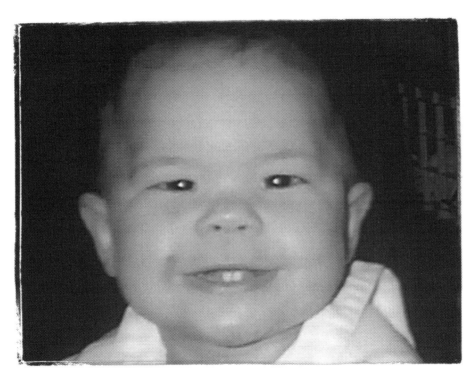

Rae' Anna Nichole • Michigan • 2:19 A.M.

I hope you learn from others, listening to the

words of the old and the young.

You will learn the most

from them.

I hope you build castles made of sand.

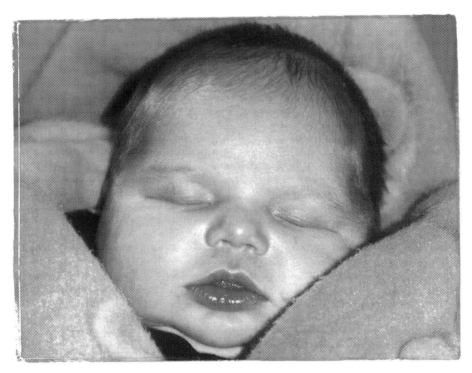

Nicholas Robert • Minnesota • 9:11 P.M.

I hope you love with all of your heart,

expecting nothing in return.

I hope you enjoy the exhilaration and freedom

of swinging on a swing, high in the air.

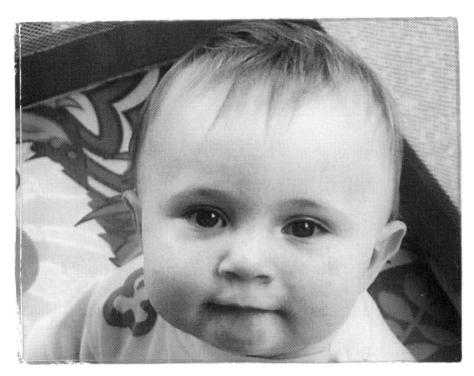

Andrew Dillon • Mississippi • 9:45 A.M.

I hope you enjoy your own company.

I hope you put a tooth under your pillow

and wait for a fairy to come.

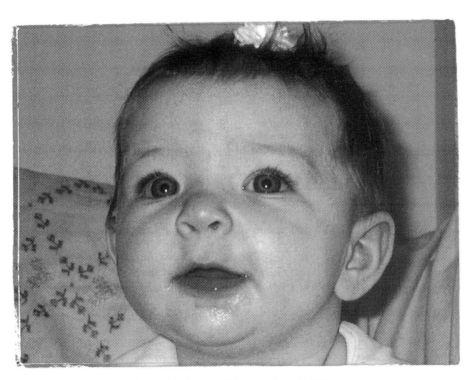

Mary Claire • Missouri • 8:09 P.M.

I hope you show compassion when others turn away.

I hope you jump in piles of autumn leaves.

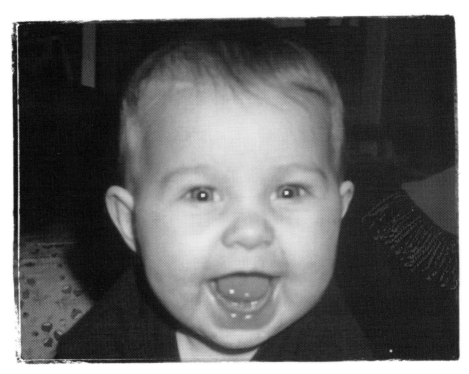

Michael John • Montana • 8:43 P.M.

I hope you skip the chance to say "I told you so."

I hope you laugh at your own reflection

in the mirror.

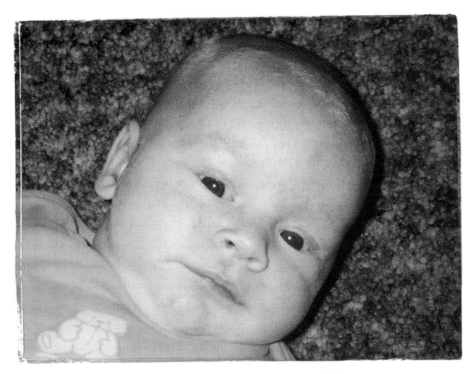

Samuel James • Nebraska • 4:59 P.M.

I hope you shed few tears of sadness

and many tears of joy.

I hope you think your daddy is a hero.

READER/CUSTOMER CARE SURVEY

HEMG

We care about your opinions! Please take a moment to fill out our online Reader Survey at **http://survey.hcibooks.com**. As a **"THANK YOU"** you will receive a **VALUABLE INSTANT COUPON** towards future book purchases as well as a **SPECIAL GIFT** available only online! Or, you may mail this card back to us.

First Name		MI.	Last Name

Address			City

State	Zip	Email	

1. Gender
□ Female □ Male

2. Age
□ 8 or younger
□ 9-12 □ 13-16
□ 17-20 □ 21-30
□ 31+

3. Did you receive this book as a gift?
□ Yes □ No

4. Annual Household Income
□ under $25,000
□ $25,000 - $34,999
□ $35,000 - $49,999
□ $50,000 - $74,999
□ over $75,000

5. What are the ages of the children living in your house?
□ 0 - 14 □ 15+

6. Marital Status
□ Single
□ Married
□ Divorced
□ Widowed

Comments

BUSINESS REPLY MAIL

FIRST-CLASS MAIL PERMIT NO 45 DEERFIELD BEACH, FL

POSTAGE WILL BE PAID BY ADDRESSEE

Health Communications, Inc.
3201 SW 15th Street
Deerfield Beach FL 33442-9875

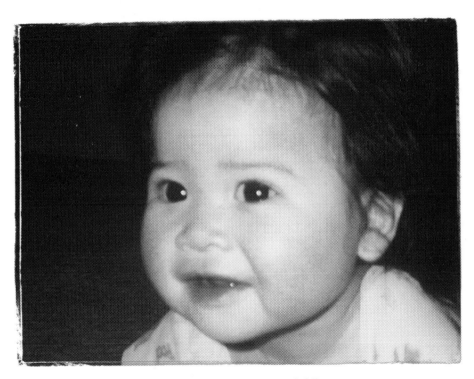

Tyra Ann • Nevada • 3:07 A.M.

I hope you care for the sick.

I hope you plant a flower in a cup and watch it grow.

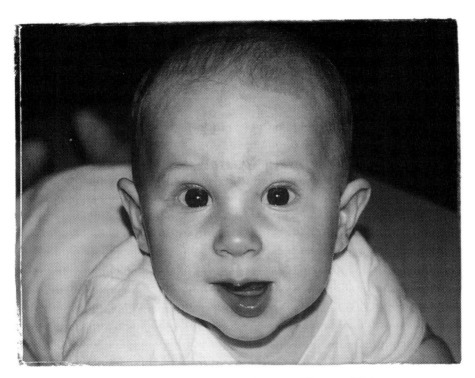

Matthew Thomas • New Hampshire • 4:34 P.M.

I hope you pledge allegiance to the American flag.

I hope you tell "Knock Knock" jokes that make no sense to anyone else, but are hysterically funny to you.

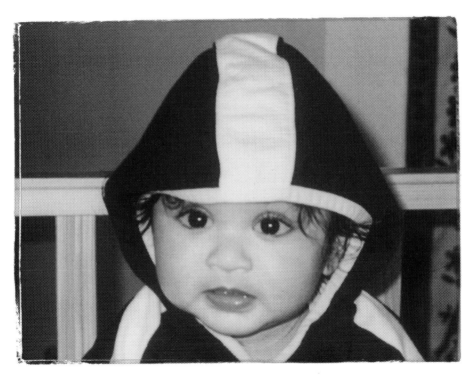

Anish • New Jersey • 10:05 A.M.

I hope you fall madly in love.

I hope you write your name with your finger

in the frost on a window.

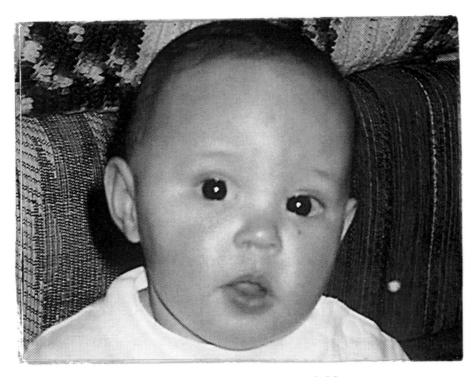

Kelsey Erin • New Mexico • 8:29 A.M.

I hope you marry and promise to love someone

for the rest of your life.

I hope you hide under the covers.

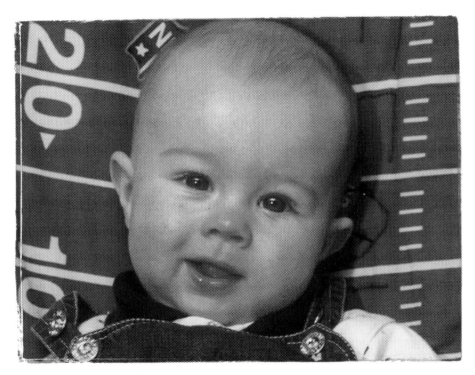

Jacob Robert • New York • 12:23 P.M.

I hope you keep your promises.

I hope you carve a face on a pumpkin

and place a lighted candle inside.

Alexis Taylor • North Carolina • 11:47 A.M.

I hope you make faces into the school bus window.

I hope you make faces out of the school bus window.

Jay Lee • North Dakota • 7:58 A.M.

I hope you become a parent and hold your newborn child in your arms.

I hope you realize how much your parents have given you and thank them.

Maxwell Stephen • Ohio • 12:07 A.M.

I hope you speak only the truth.

I hope you have grandparents who let you

do anything you want.

Sarah Brett • Oklahoma • 8:19 P.M.

I hope you believe in angels and know

that they are all around us.

I hope you raise a pet from when it is young,

give it a good life, then a proper good-bye.

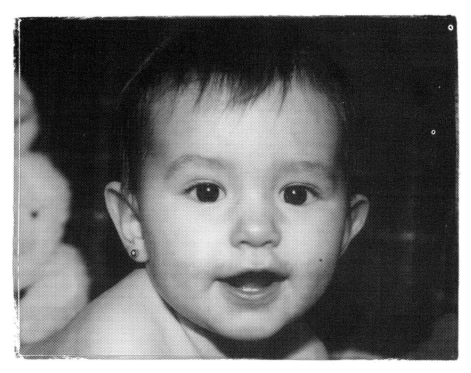

Ana Maria • Oregon • 5:42 P.M.

I hope you sit at a Thanksgiving table, hold hands with

those around you and know that you are blessed.

I hope you write love letters

from deep inside your heart.

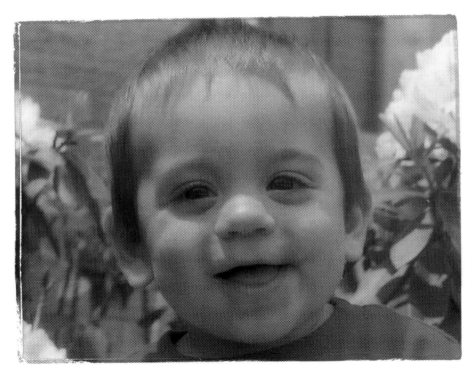

Trevor Sami • Pennsylvania • 2:07 P.M.

I hope you experience the blessing of friendship.

I hope you kick and scream

just because it makes you feel better.

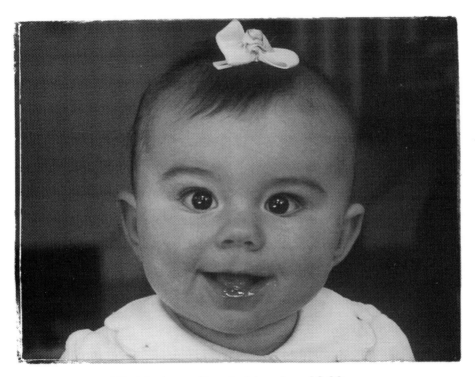

Lilly Marie • Rhode Island • 12:38 P.M.

I hope you tell only white lies.

I hope you ask, "Are we there yet?"

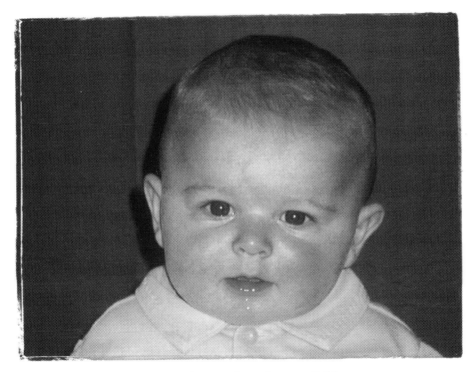

Carson • South Carolina • 5:18 P.M.

I hope you fly the American flag

on the home where you live.

I hope you watch the sun rise

and set any chance you get.

Kathie Jean • South Dakota • Katie Rose
5:43 P.M. 5:54 P.M.

I hope you do kindnesses because you want to, never seeking the credit.

I hope you turn your face toward the sun, close your eyes and feel its warmth.

Benjamin • Tennessee • 1:44 P.M.

I hope you become a grandparent.

I hope someone dresses you like a

pumpkin on your first Halloween.

Carson Wil • Texas • Collin Levi
7:56 A.M. 7:57 A.M.

I hope you are a peacemaker.

I hope you wear pajamas with feet in them.

Hayes Christopher • Utah • 5:24 A.M.

I hope you live long, enjoy your history

and pass it on to the young.

I hope you throw pennies in a fountain.

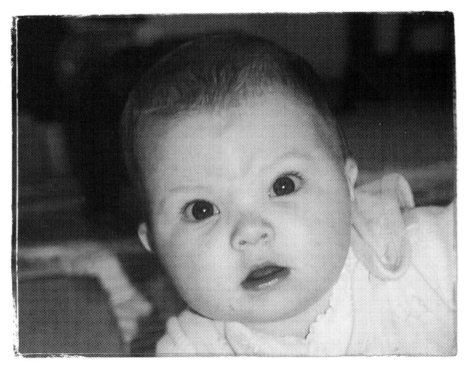

Emma • Vermont • 11:03 A.M.

I hope you search for hope when it is difficult to find.

I hope you talk baby talk to a baby.

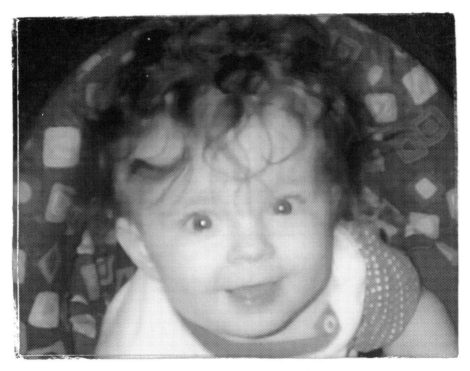

Kelly Brooke • Virginia • 2:39 A.M.

I hope you forgive when it is deserved

and when it is not deserved.

I hope you catch lightning bugs

on warm summer nights.

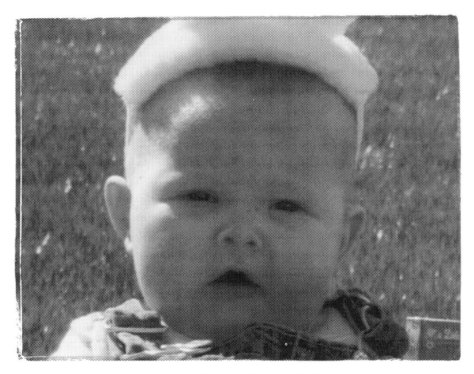

Jayna • Washington • 6:00 P.M.

I hope you are brave and show courage

just like you did on the day that you were born.

I hope you always get a good-night kiss.

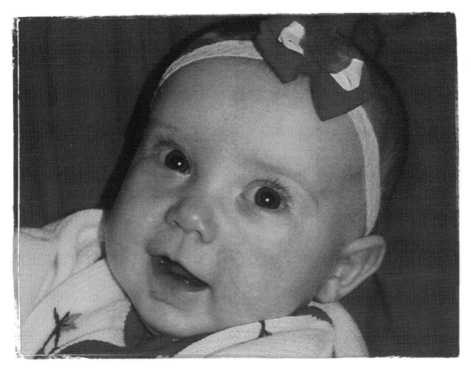

Hattie Elaine • West Virginia • 11:15 A.M.

I hope you will be good.

I hope you feel safe in your bed.

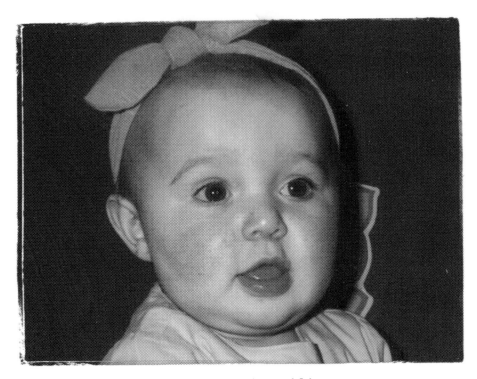

Karis • Wisconsin • 4:16 P.M.

I hope you will make the world a better place.

I know that you will.

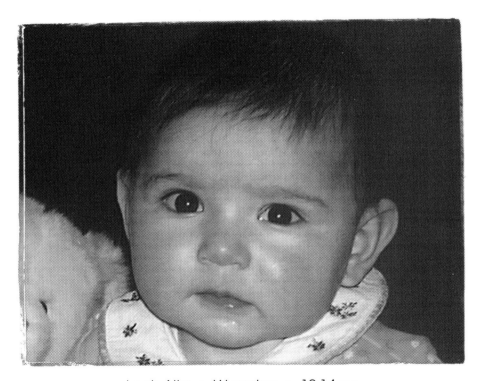

Leah Alta • Wyoming • 12:14 P.M.

Hammond

Afterword

I have a tradition: On the day that each of my children was born, I wrote him or her a letter. In these letters, I described the feelings I had both for them and about the world I had just helped them join. I continued this custom with my third child, Trevor, when he was born on September 11, 2001. That letter is how this book began.

Just as each child is unique, the emotions that go along with having him or her are unique as well. I couldn't help but wonder how the other moms who had babies on 9-11 were feeling. As I sat in my hospital bed, I realized that in every state in America sat another mom just like me who had given birth on this tragic day.

I visualized the babies as tiny spots of hope placed perfectly within every state. Tiny spots of light that were illuminating our country just like single candles placed in the windows of a home glowing softly in the dark night. Whenever I pass by a house like that, I slow down to "feel" the warmth that comes from them. I always think, "Hope lives there." These babies were the hope and the light that was uniting our country as one home.

I wondered what the other moms were thinking. Did they know that

they were holding hope in their arms? Could they see the light surrounding their babies? I wanted to reach out to them. I wanted to tell them how I felt, and I wanted to listen to how they were feeling.

What began as a curious Internet surf of the birth announcement sections of newspapers turned into a quest to find a baby (and a mom) from each of the fifty states. I discovered and was blessed with so much more than I could have ever expected. I found fifty moms who kindly shared their stories with me and graciously agreed to offer a photo of their precious bundle. From my heart, I thank them for that. That is how the rest of the book came to be.

Through it all, I feel as if I've made fifty new girlfriends. I joke with them that we have the largest playgroup going. Most playgroups include everyone in the neighborhood; ours includes everyone in the country. Most playgroups rotate houses; we'll rotate states. Maybe we won't get together fifty times, but our wish is to get together once, all in the same place, to show off our brave little ones who were born on that tragic day that no one will ever forget. Like all new moms, I know we'll share our mishaps as well as our stellar moments. I know we'll laugh a little about silly feelings we had. I know we'll cry a little about the tragedy that came. I know we'll thank God for our babies. And I know that we'll thank God for the U.S.A.